Mystical
MOODS OF IRELAND
Portals Through Time:
Irish Doorways & Windows

Volume VI

Praise for James A. Truett's work...

"Your gorgeous photos are works of art along with the musings. Here in West Virginia, I can be transported to magical Ireland where my spirit lives. Thank you for the joy and the calm each breathtaking photo gives. My imagination runs wild with your images." ~ **Ann Burdette**

"James, your doorways and windows open passages from our hearts and minds to the beauty of the world. These photos touch our souls in profound ways. Thank you!" ~ **Judy Long**

"You bring Ireland to my heart and nourish my soul everyday." ~ **Cheryl Phillips**

"Having visited Ireland I can see how the photography of James Truett captures not only the beauty, but also the spirit of this lovely island." ~ **Anne Lackey**

"Capturing the magic of the mystic mists of Ireland, not always an easy task, this book, through the camera lens of the author, does just that. Enjoy!" ~ **Gail Burger**

"Makes me feel so calm and thoughtful when I see your work, I can tell you love what you do. It brings peace to my soul, and closer to my creator. Someday I will visit Ireland, but for now, I see it through your eyes." ~ **Ethel Dixon**

"James Truett is such a talented photographer! I absolutely love his enthralling pictures of Ireland! He literally brings his beautiful scenes to life for me! I do hope to visit soon, and would love to meet him!! I'm definitely a fan!!" ~ **Donnis Schrader**

"James Truett has a keen eye for selecting the perfect location for photos. And now, after visiting Ireland myself, I have seen firsthand how he really captures the essence of Ireland. It is a pleasure to own all his books and calendars." ~ **Celeste Goering**

Mystical MOODS OF IRELAND

Portals Through Time: Irish Doorways & Windows

Volume VI

James A. Truett

www.JamesTruettBooks.Com

TrueStar Publishing

UNITED STATES · IRELAND

Published by TrueStar Publishing
United States • Ireland
www.TrueStarPublishing.Com

Ordering Information:
All products in the Moods of Ireland series including books, calendars, posters, cards and prints are available at special quantity discounts for bulk purchases for sales promotions, premiums, fund raising, educational, corporate or institutional use. Specially customized books, calendars, posters, cards and prints can also be created to fit specific needs. For details, please e-mail the publisher at:
specialsales@truestarpublishing.com

PBK-ISBN: 978-1-948522-10-6
PBK-ISBN-10: 1-948522-10-1

HBK-ISBN: 978-1-948522-11-3
HBK-ISBN-10: 1-948522-11-X

First Edition: August 2018

10 9 8 7 6 5 4 3 2 1

COVER: *"Tranquil Irish Path" by James A. Truett.*

Dedication

In memory of my friend
Michael McNamara
December 27, 1944 - April 7, 2017

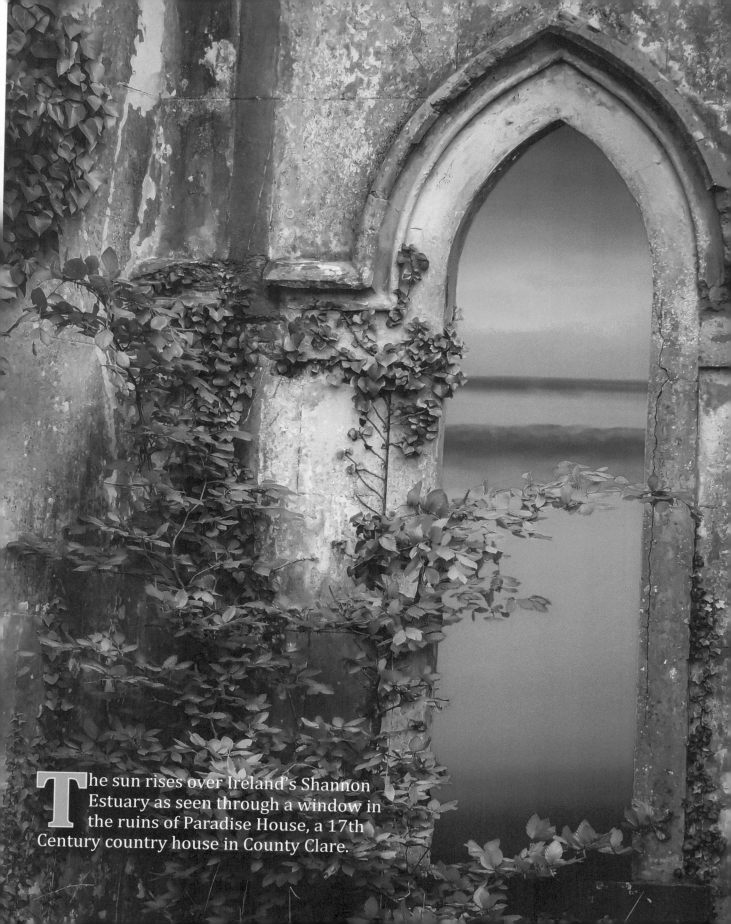

The sun rises over Ireland's Shannon Estuary as seen through a window in the ruins of Paradise House, a 17th Century country house in County Clare.

Introduction

Portals through Time: Irish Doorways and Windows

This collection of images was born out of a combination of wonder, frustration and imagination — Wonder in the natural beauty of Ireland and its ruins; Frustration that most sites open onto the sadness of graveyards or nature's overgrowth; and, Imagination in thinking "what if" these historical scenes could accentuate the Emerald Isle's abundant beauty while honouring bygone eras.

I wanted to bring together the past and the present... Remnants of architecture delicately sculpted many years ago — in many cases centuries ago — melded with present-day scenery found in the magical Irish countryside.

Compositing is a relatively new artform that allows an artist to accomplish this through the blending of multiple images into one final piece — old and new combined to elicit a range of emotions not fully experienced in simple images.

My hope is that you feel the amazing depth and timeless respect for the artisans, builders and residents who created the structures that frame each scene, and that you experience with child-like wonder the present-day scenery that resurrects itself each year in spectacular vistas and abundant colours.

Go raibh mile maith agat! *(A thousand thank yous!)*

James A. Truett
County Clare, Ireland

Spring Rainbow over Shannon Estuary

A brilliant Spring rainbow shines over Ireland's Shannon Estuary, as seen through the Medieval arched doorway of Dysert O'Dea Castle in County Clare.

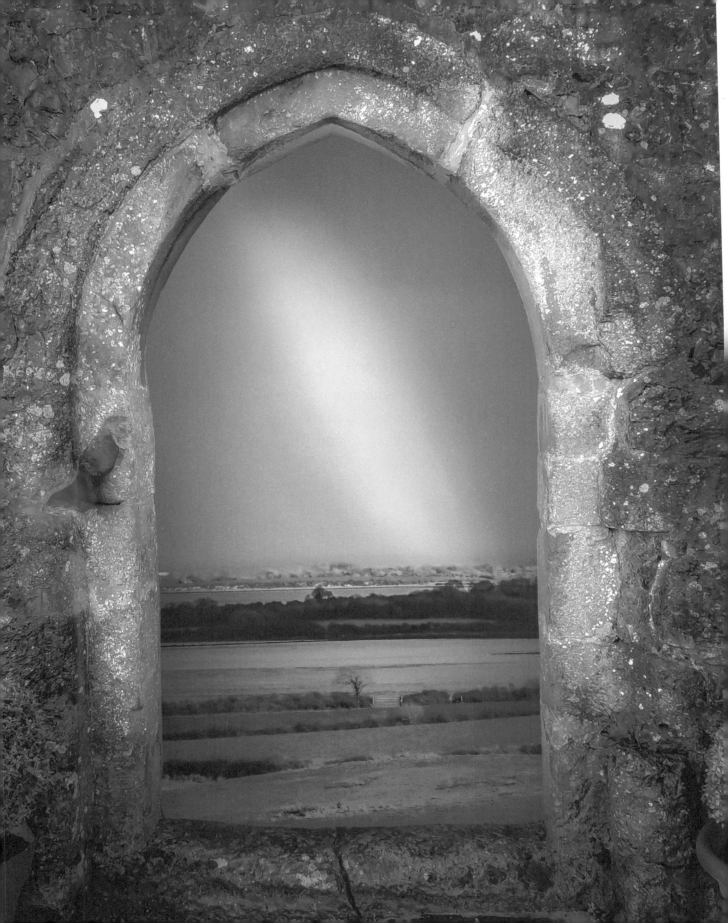

Rainbow over County Clare, Ireland

An ivy-encased window in an abandoned 19th Century mill on the shores of the River Fergus at Lake Inchiquin frames a stunning rainbow in the hills of Ireland's County Clare.

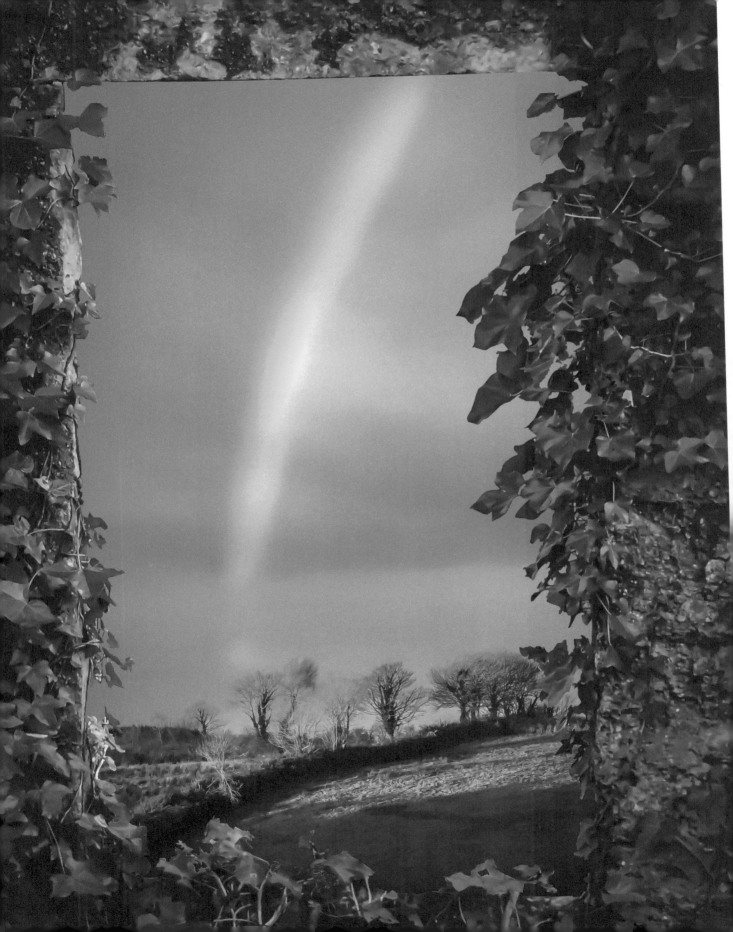

Rainbow in Paradise, County Clare

A spectacular Irish rainbow and gorgeous Great Willowherb blossoms reaching for the sky are viewed through a window in the ruins of Paradise House, a once stately home built in the 1600s in County Clare and destroyed by fire in 1970. Nature is taking over.

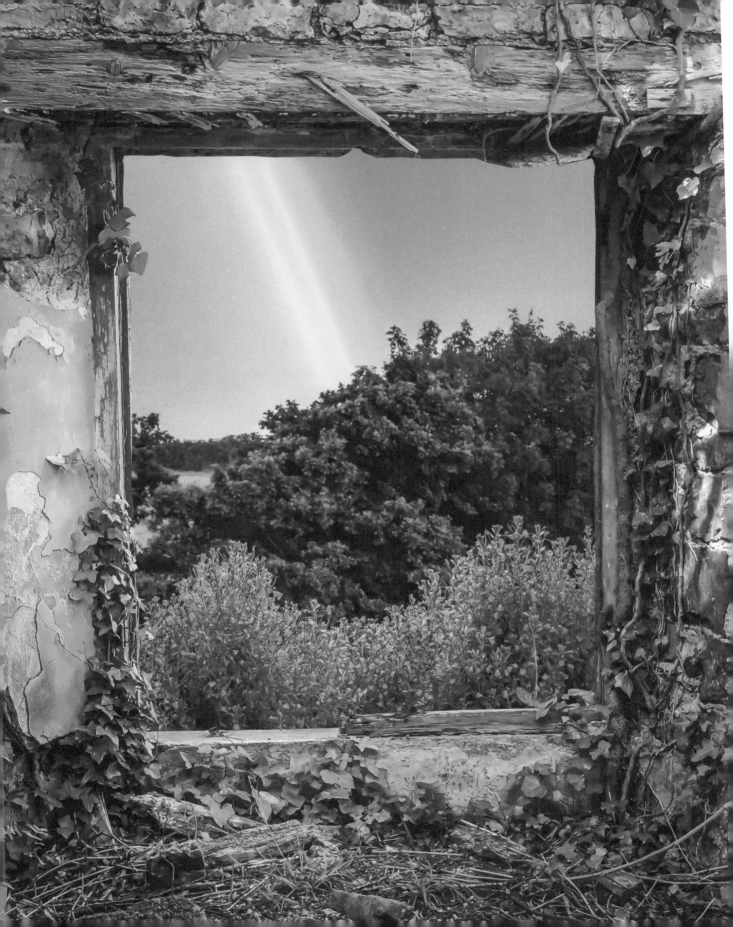

Magical County Clare Countryside

The magical Irish countryside comes alive each Spring with blooming Cherry blossoms and Tulips, as in this scene captured in April 2017 near the village of Quin in County Clare. The weathered stone wall is from a carriage house at Doneraile Park in County Cork.

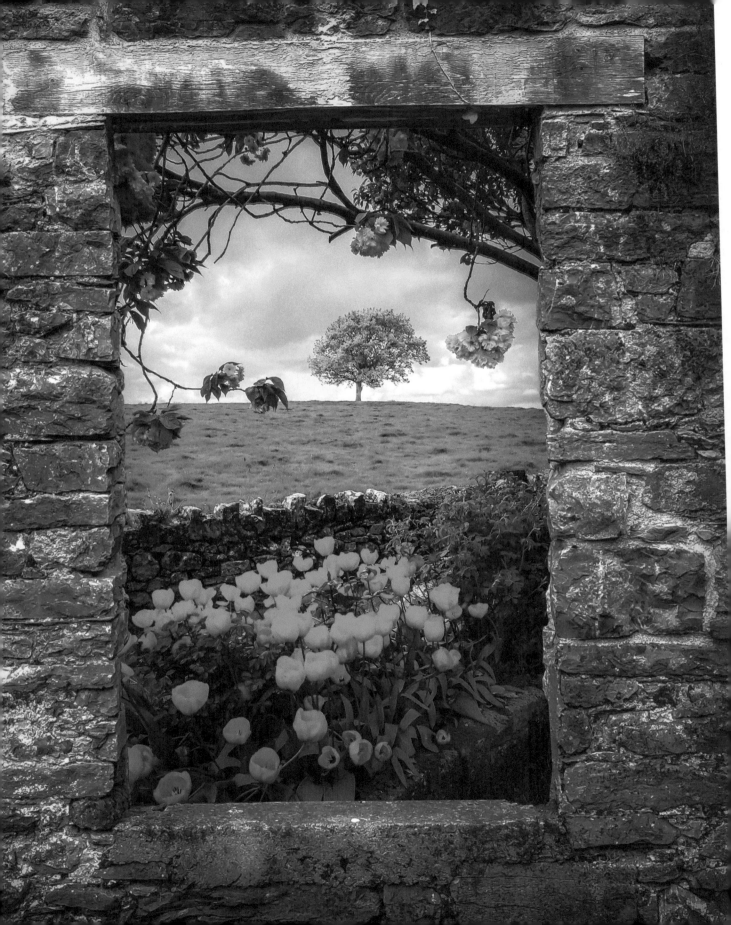

Wild Irish Roses in County Galway

This image takes us to County Galway and an old Miller's Cottage near Thoor Ballylee, summer home to Nobel Laureate W. B. Yeats. Here, a window in the ruins of the stone cottage opens onto a bush of wild Irish Roses also in the County Galway countryside.

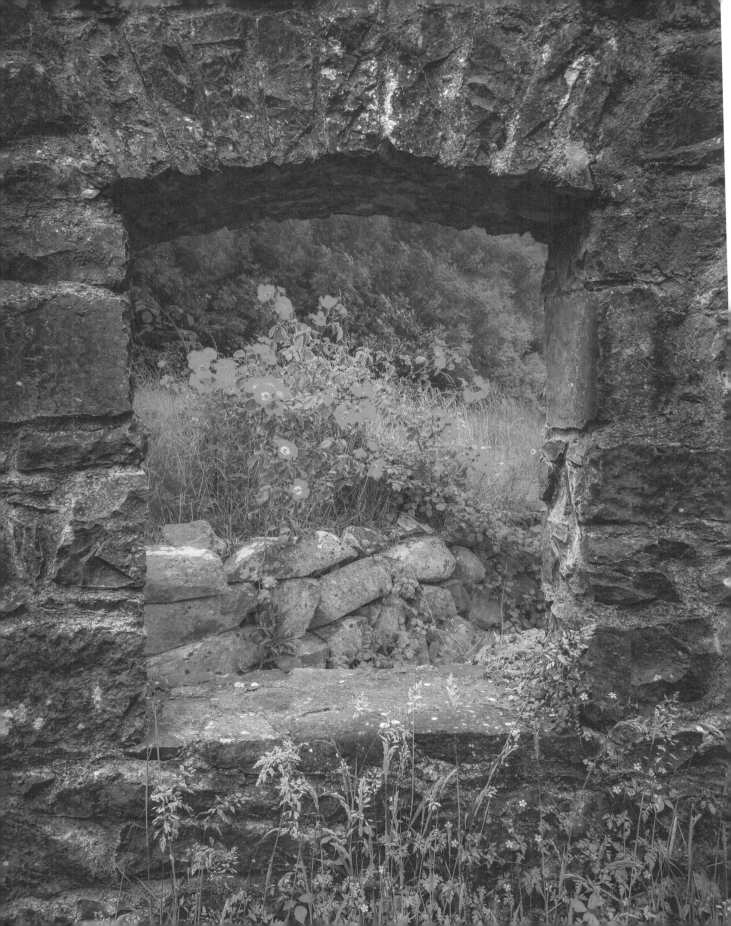

Along the Shannon Estuary

Wildflowers including Daisies and Foxglove brighten the roadside along Ireland's Shannon Estuary, as seen through an arched entrance in the ruins of a church in the Old Burrane graveyard at Killimer, with graves dating back to 1794. River travel once provided the primary mode of transport for distribution of supplies in this part of Ireland.

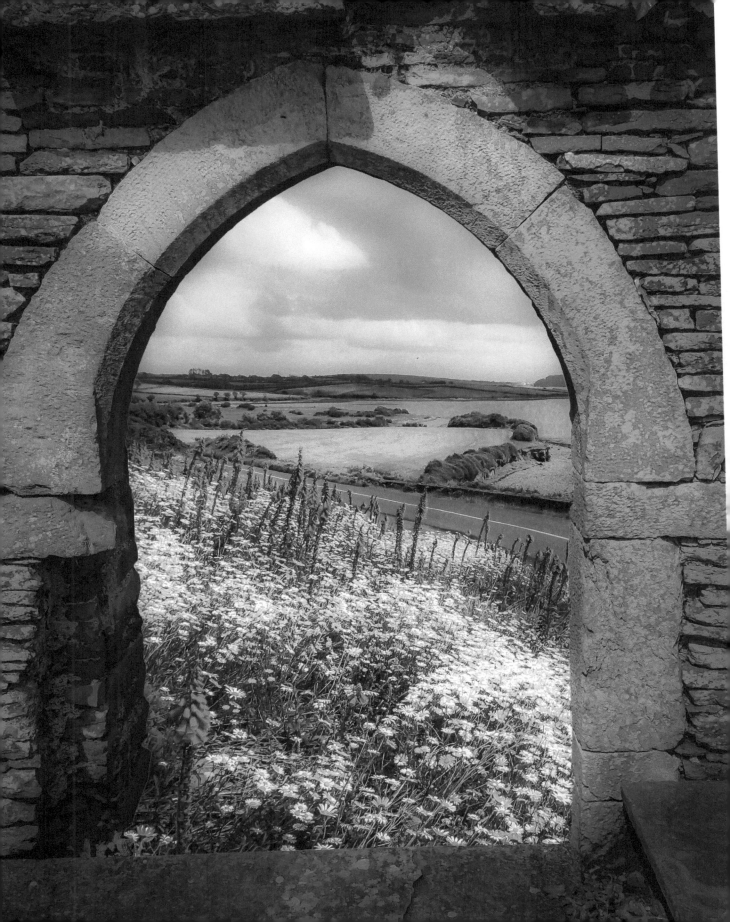

Wildflowers on Galway Bay

Spritely coloured wildflowers on the shores of picturesque Galway Bay are viewed through one of the 19th Century arched doorways of nearby St. Mary's Church at Claddagh Quay in Galway City. This building features rock-faced granite walls and rounded arches with intricate carvings. Ireland's National Inventory of Architectural Heritage describes it as "a good example of the return of the Romanesque style linked with the Celtic Revival-style church architecture of the late 19th century."

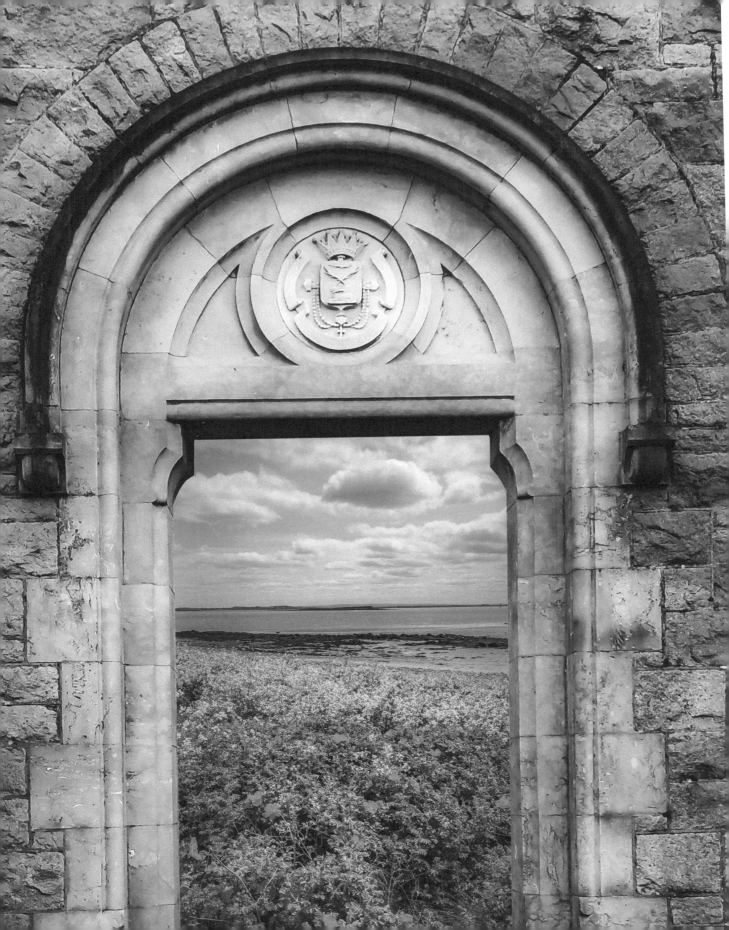

Into the County Galway Countryside

The elegant facade of a 19th Century terrace home in Galway City provides the frame for this composite image enticing visitors to step into the otherworldly 'Faerie Forest' at Thoor Ballylee, summer home to Nobel Laureate W. B. Yeats near Gort, also in County Galway.

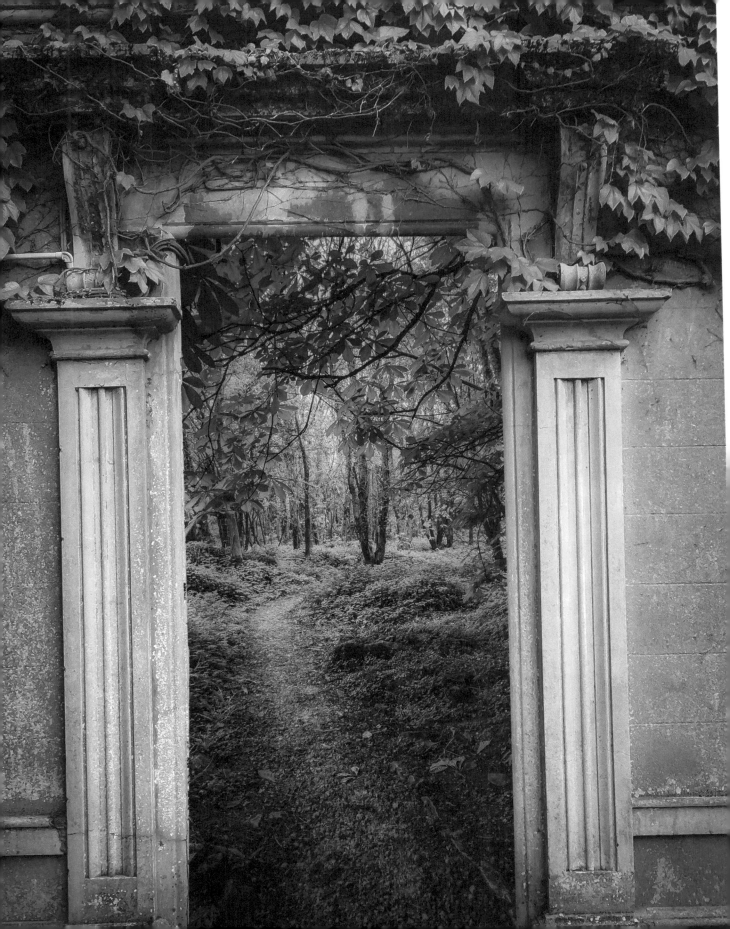

Portal to Portumna Forest

The artful entrance to Columban Hall, built in Galway City in 1863, opens onto a path wandering through Portumna Forest Park, also in County Galway.

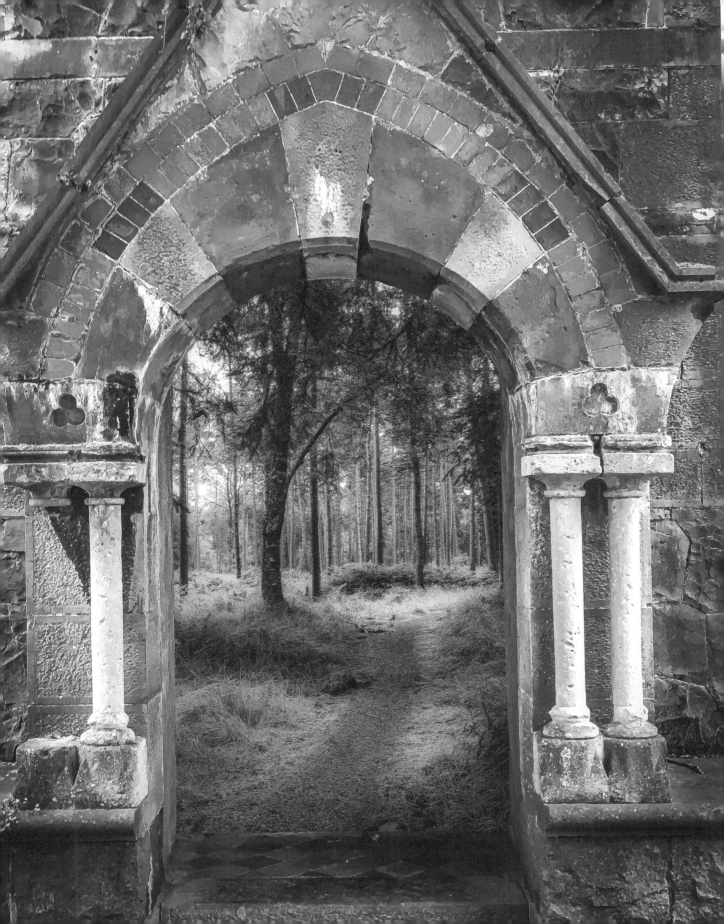

Path to Quin Abbey, County Clare

One of the intricately carved doorways within Ireland's Quin Abbey frames a scene of the Abbey itself. History is quite deep here. This Medieval Abbey in Quin, County Clare, was established in the 1400s on the site of an earlier monastery from 1250 A.D. Once considered one of the foremost institutions of higher religious learning in Europe, Quin Abbey has endured fires, attacks and massacres. The last Friar died in 1820, and the Abbey became a National Monument of Ireland in 1880.

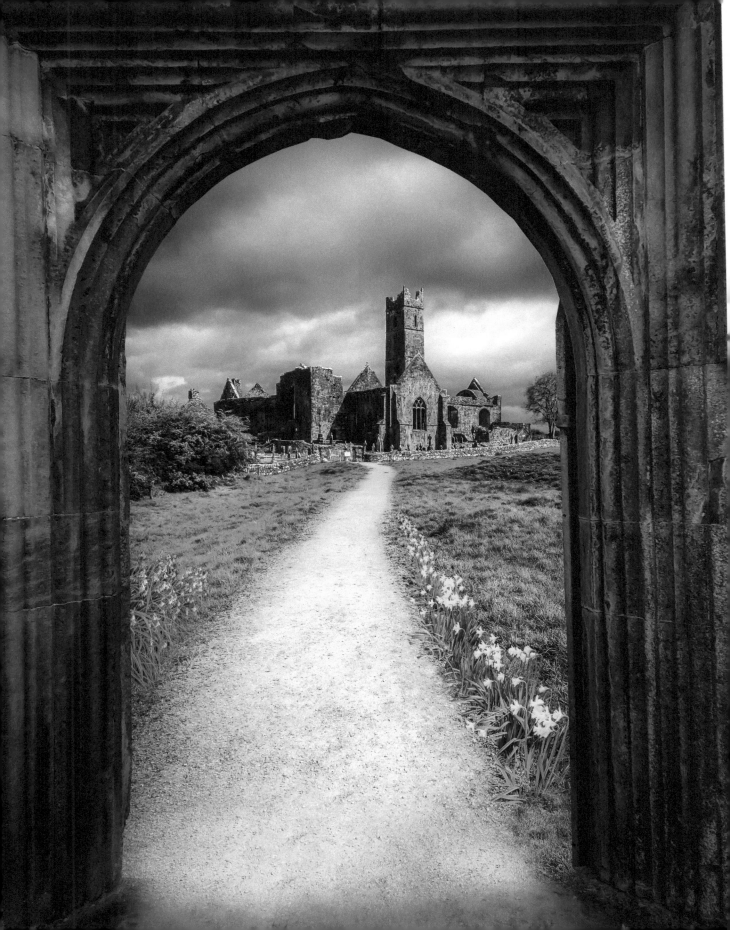

Setting Sun on the River Shannon

A Summer setting sun reflects on the calm waters of the Shannon River near the village of Roosky in County Roscommon, as seen through a Medieval arch from Cahir Castle in County Tipperary.

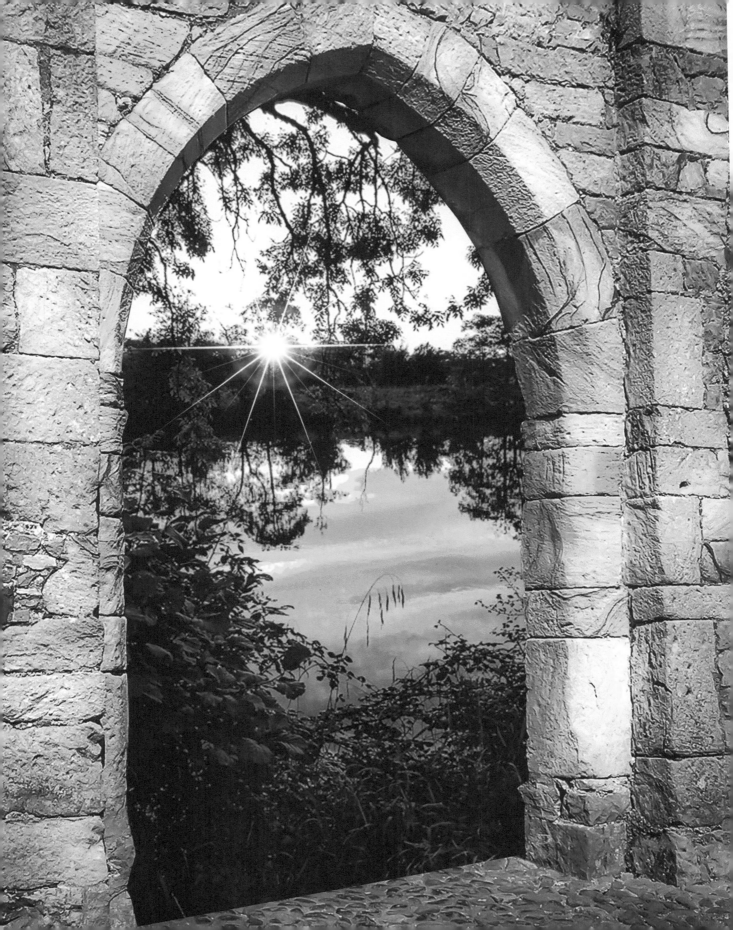

Medieval Abbey in Irish Spring

A lovely Irish Spring scene is viewed through one of the ornately crafted windows in the cloisters within Ireland's 12th Century Quin Abbey in County Clare.

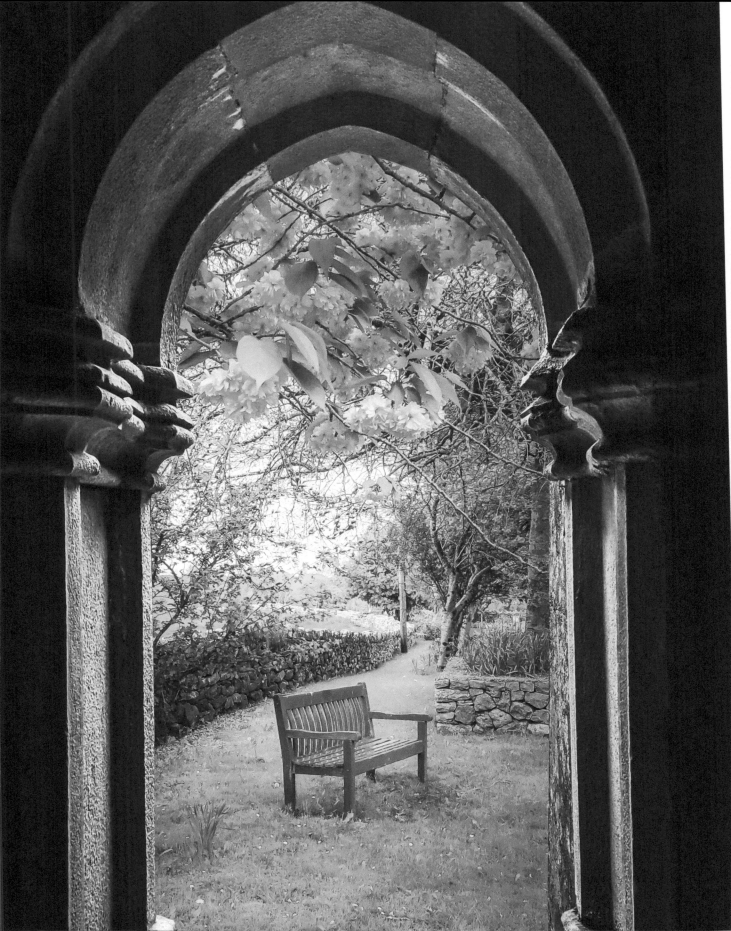

Into Irish Spring

A lush Irish Spring scene with Cherry Blossoms in the County Clare countryside is framed by a Medieval arched doorway from Ireland's Rock of Cashel in County Tipperary.

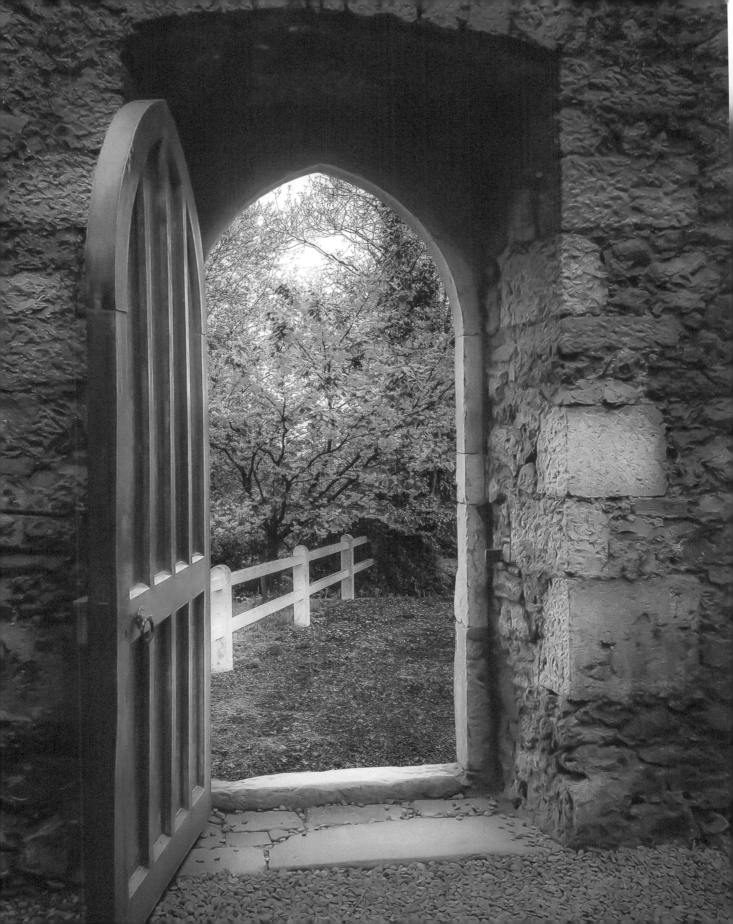

Blooming Bush in County Clare

Brightly blooming Cottoneaster bushes hang over a rock wall in County Clare, framed by this 15th Century doorway in the ruins behind Ormond Castle in County Tipperary.

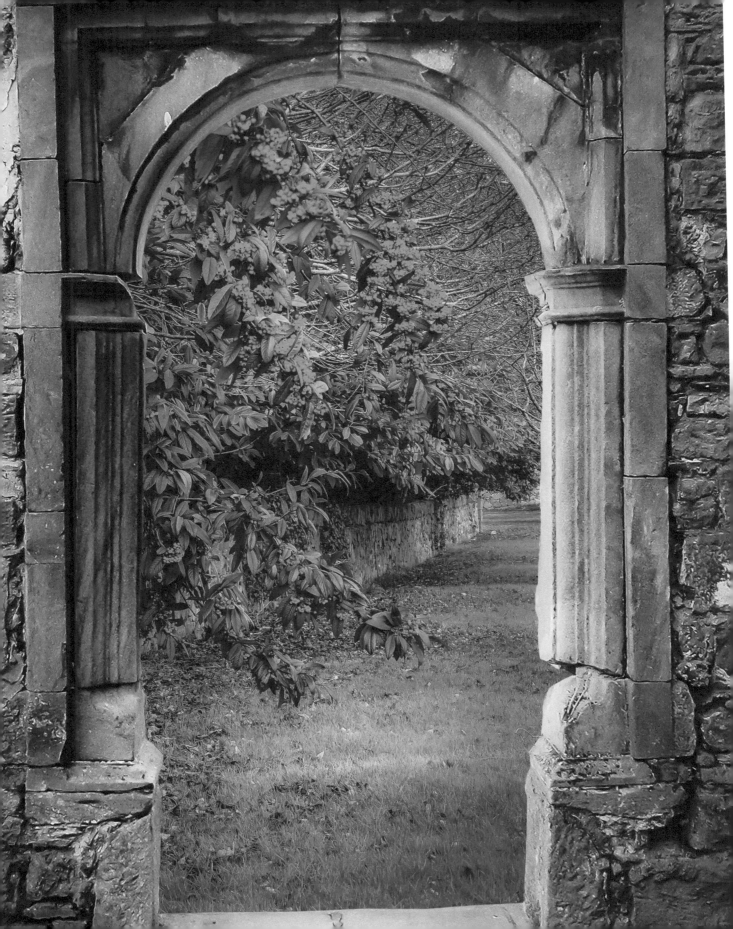

Secret Irish Garden

In the 19th Century, this stone doorway opened into the walled garden of Adelphi House, a private estate in County Clare. In this composite, it frames a lovely view from the nearby Aillwee Cave in Ireland's Burren region.

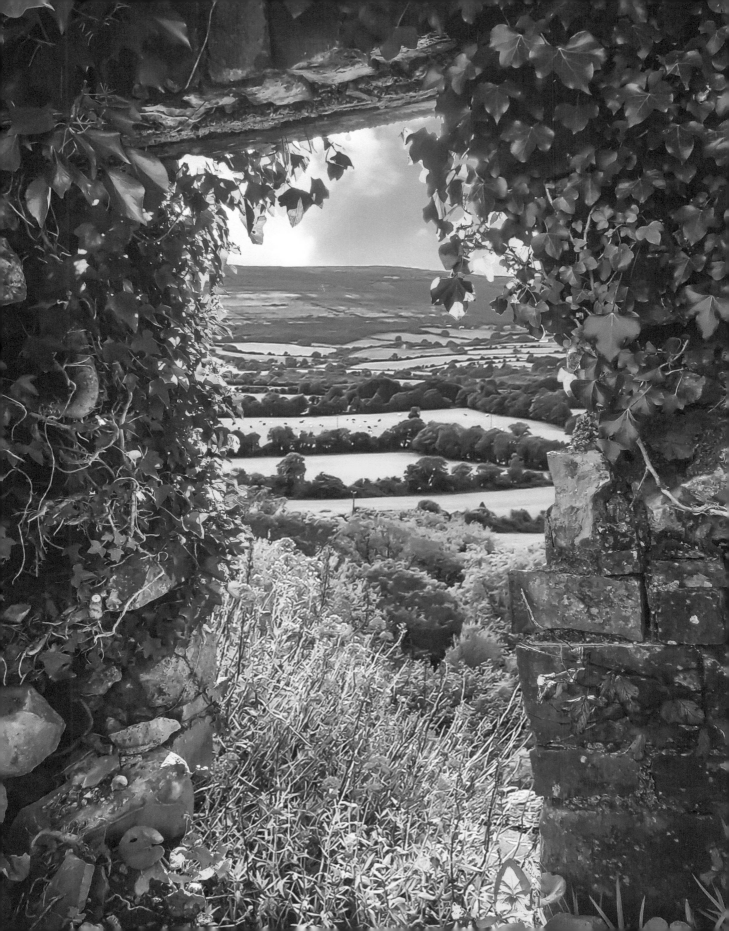

Tranquil Irish Path

This arched portal was an entrance to a gate lodge at County Clare's Newhall Estate, a once impressive 18th Century property near Ennis. Here, this lovely brick doorway frames a path into the tranquil Irish countryside.

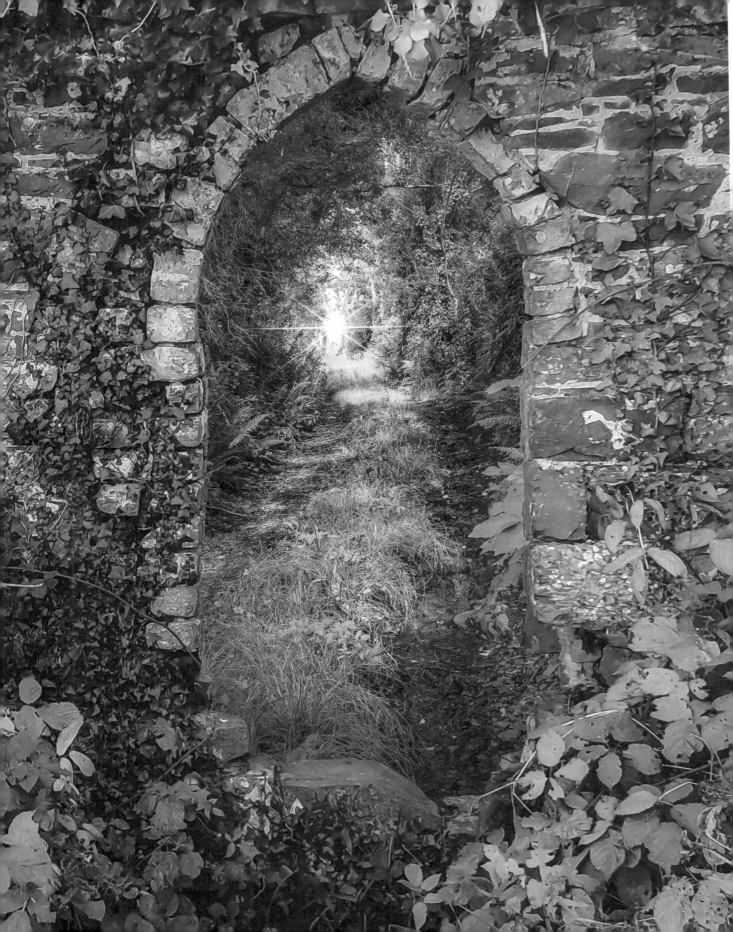

Horse in the Irish Countryside

A stone entrance to the walled garden of a private Victorian Estate in County Clare frames a typical Irish scene with a horse in a wildflower-dotted meadow.

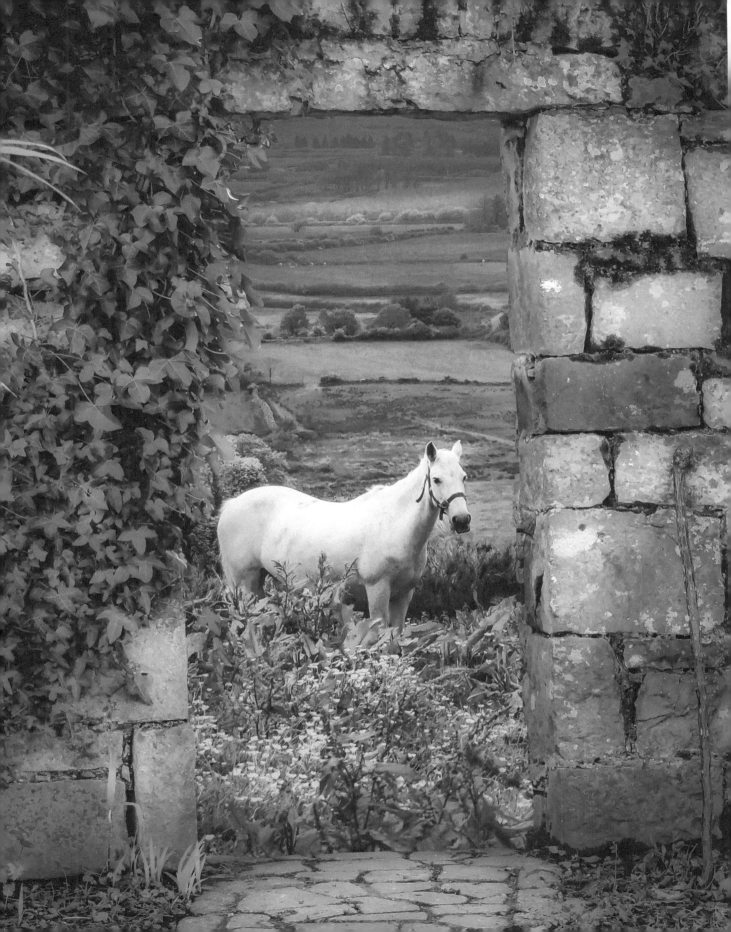

Horse at Sunrise in County Clare

The arched entrance to the cathedral at Rock of Cashel, County Tipperary, built between 1235 and 1270, frames this stunning view of the County Clare countryside at sunrise.

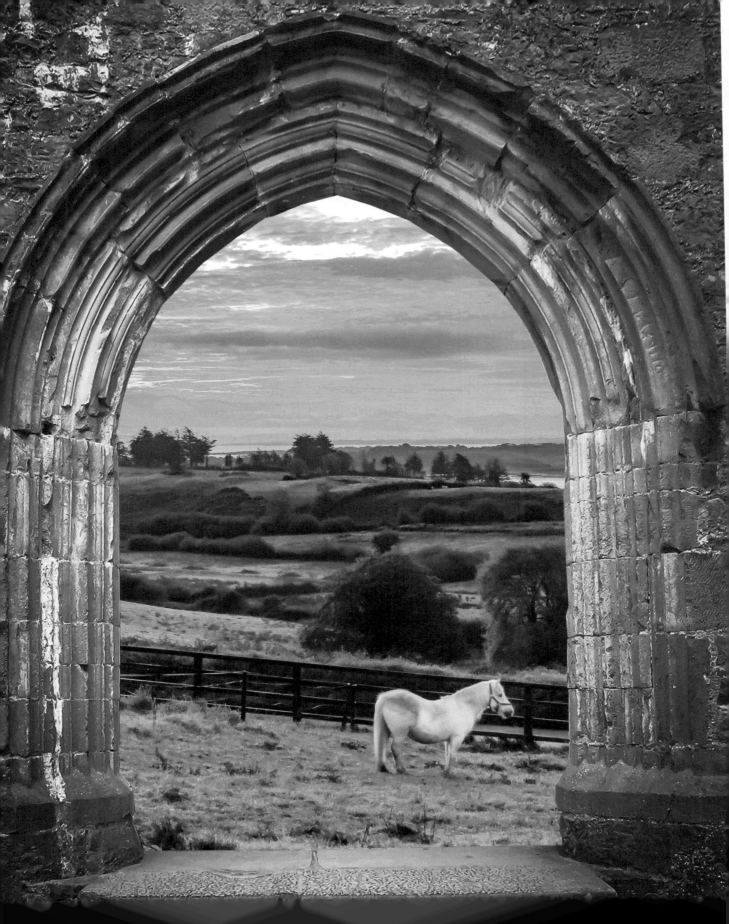

Medieval Vista of Dysert O'Dea Castle

Hundreds of years of Irish history are reflected in this scene, as an arched doorway in the ruins of one of the buildings at Clonmacnoise, a 6th Century monastic settlement in County Offaly, frames this view of the 15th Century Dysert O'Dea Castle near Corofin in County Clare.

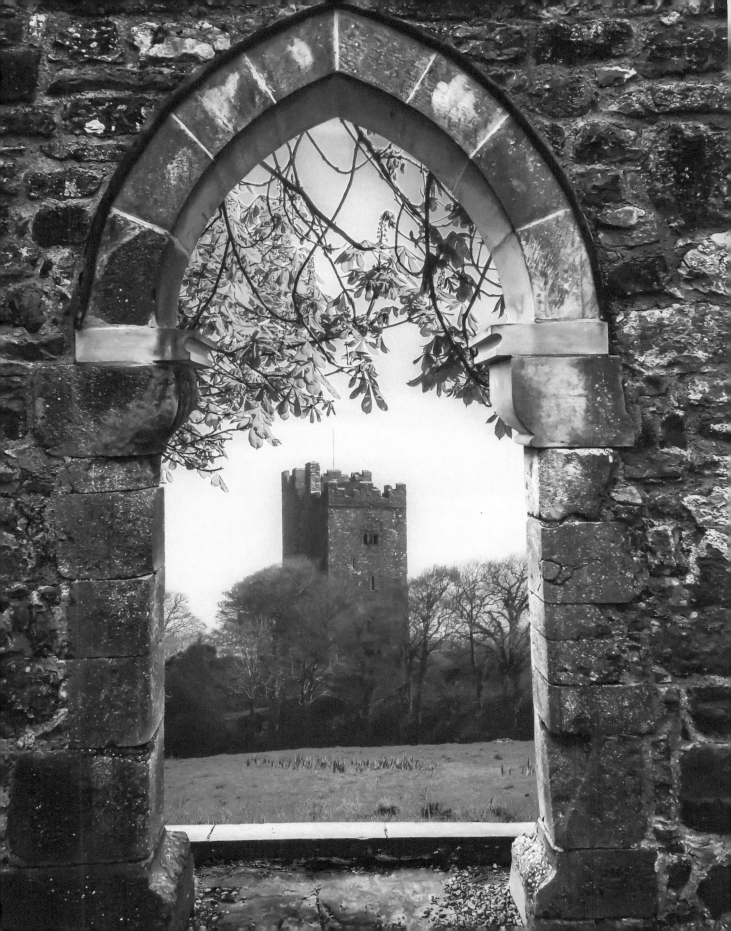

Ballinalacken Castle in County Clare

Ballinalacken Castle has a commanding view of the County Clare countryside from a hillside between Doolin and Lisdoonvarna. Here, the Medieval fortress is framed by an arched entrance in one of the castle's surrounding walls. It was founded in the 10th Century by the O'Connor Clan and subsequently taken over and rebuilt by the O'Briens in the 14th Century.

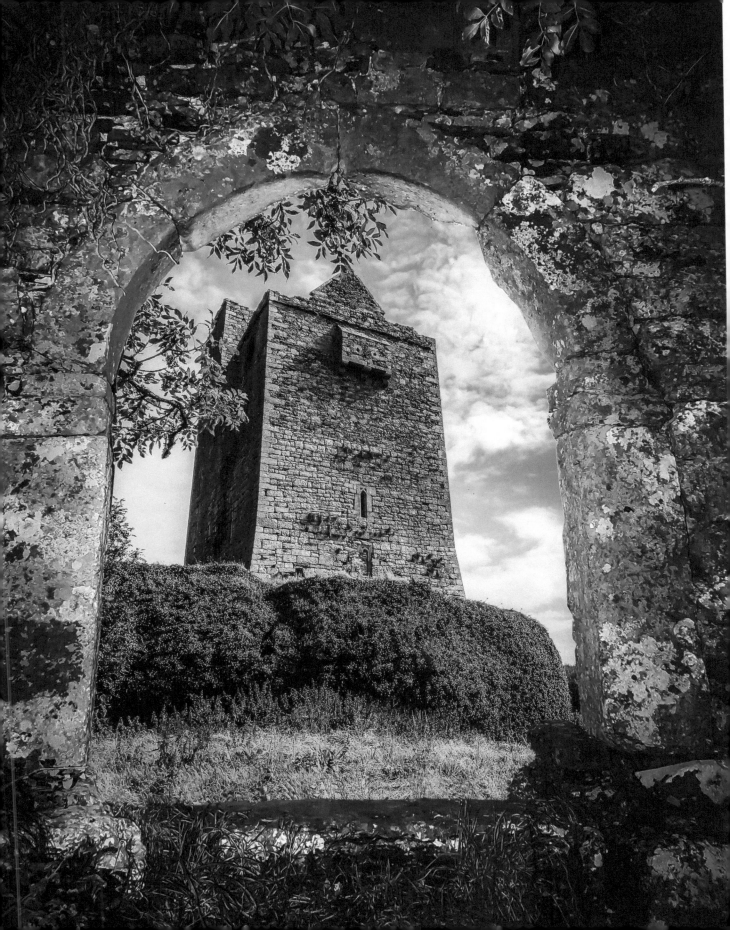

Sculpted Portal to Irish Spring Garden

This unique arched doorway is from the cathedral at Ireland's historic Clonmacnoise monastic settlement, established in the mid 6th Century in County Offaly. Here, the arch is used to frame a Spring scene of the stone wall from an abandoned cottage in County Clare.

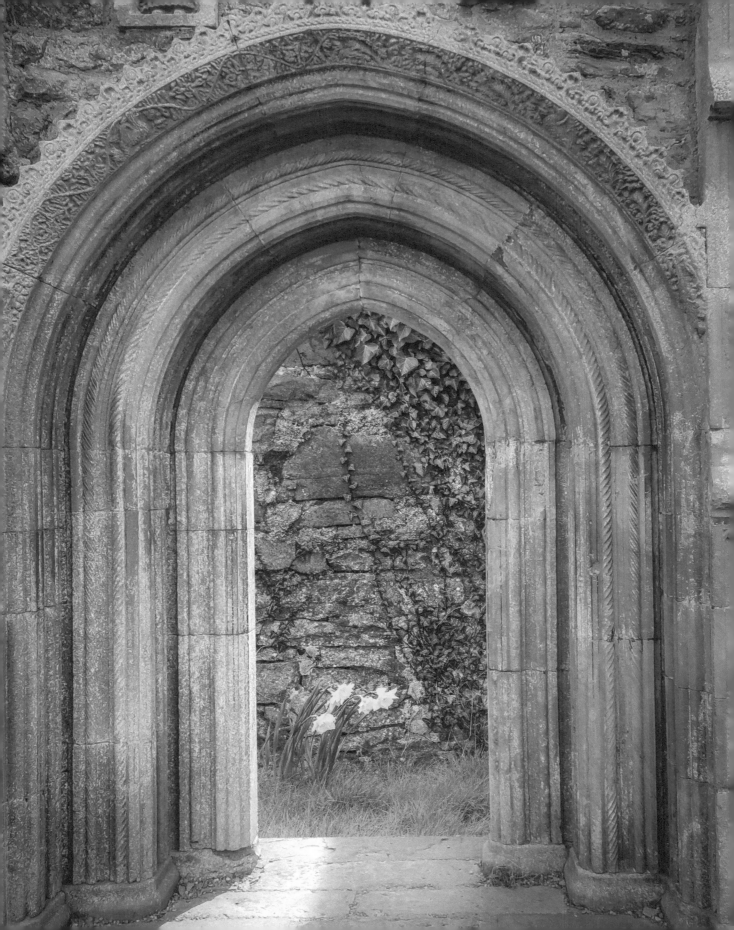

Medieval Irish Countryside

A magnificent arch at Clonmacnoise, Ireland's ancient monastic settlement founded in 544 A.D. in County Offaly, frames a Celtic High Cross and O'Rourke's Round Tower.

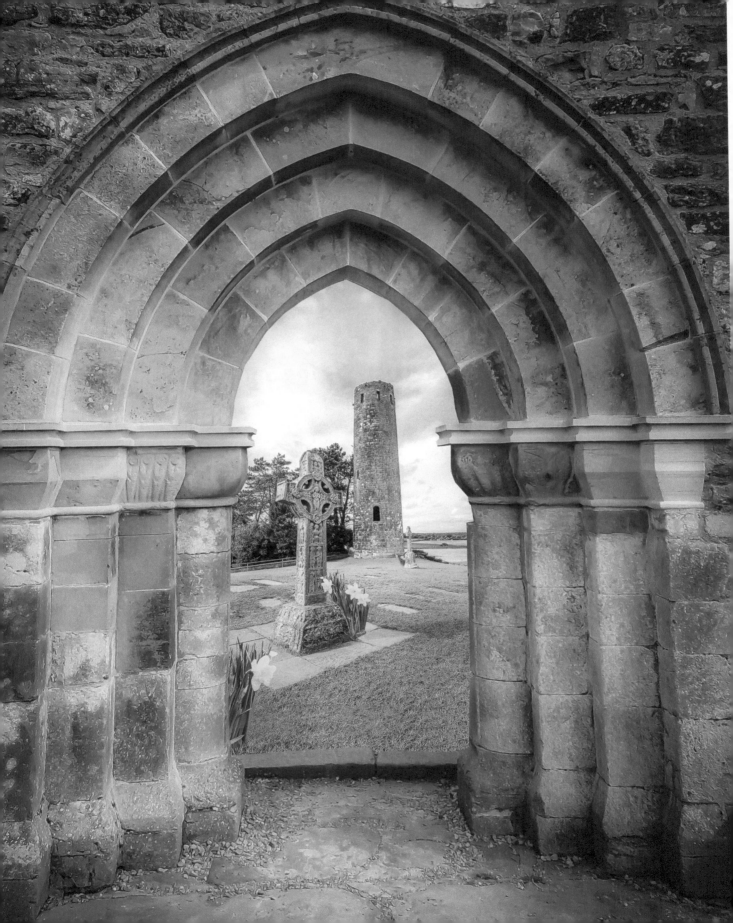

Magical Irish Spring Sunrise

This lovely sunrise over the Shannon Estuary is framed by a window in the ruins of the old church in County Clare's Clondegad Graveyard.

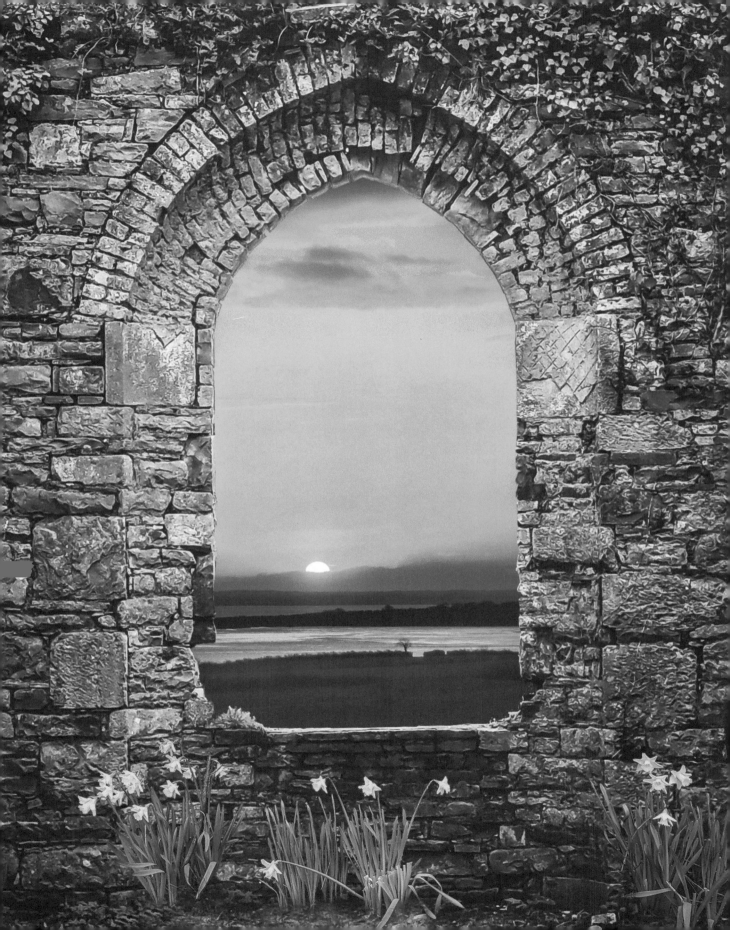

Spring in Ballynacally, County Clare

A lush Spring scene in the village of Ballynacally, County Clare, is framed by an ornate but withering window in the ruins of the church in nearby Clondegad Graveyard.

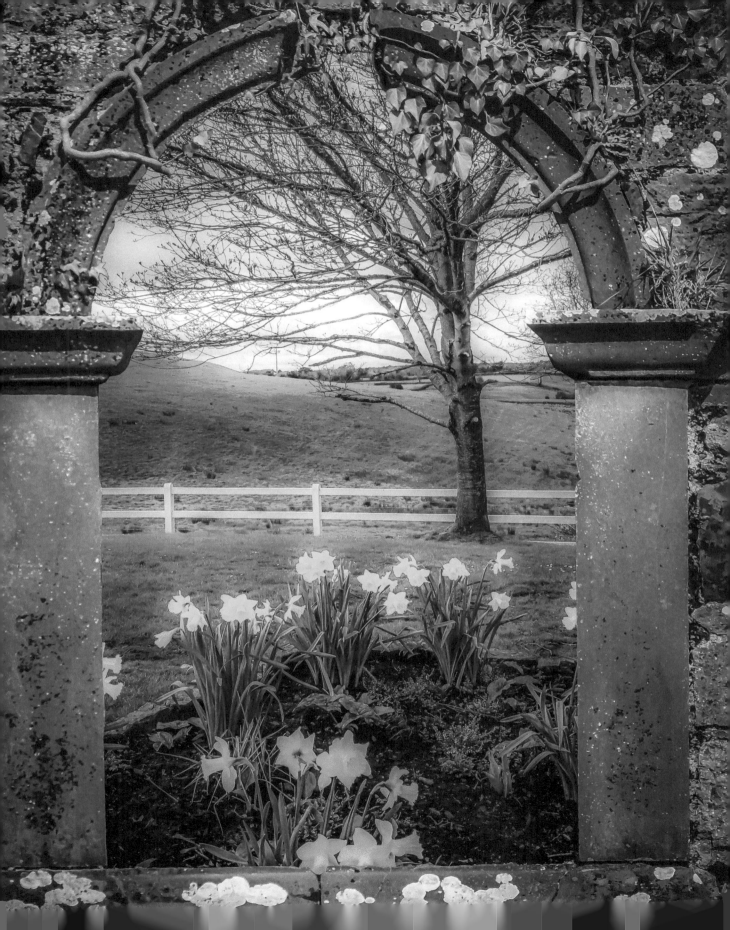

Medieval Arch and High Cross, County Clare

The 12th Century High Cross near Dysert O'Dea Castle is framed by the illuminated doorway to the nearby Romanesque Church built on the site of an early Christian monastery founded by St. Tola in the 8th Century, all near Corofin in County Clare.

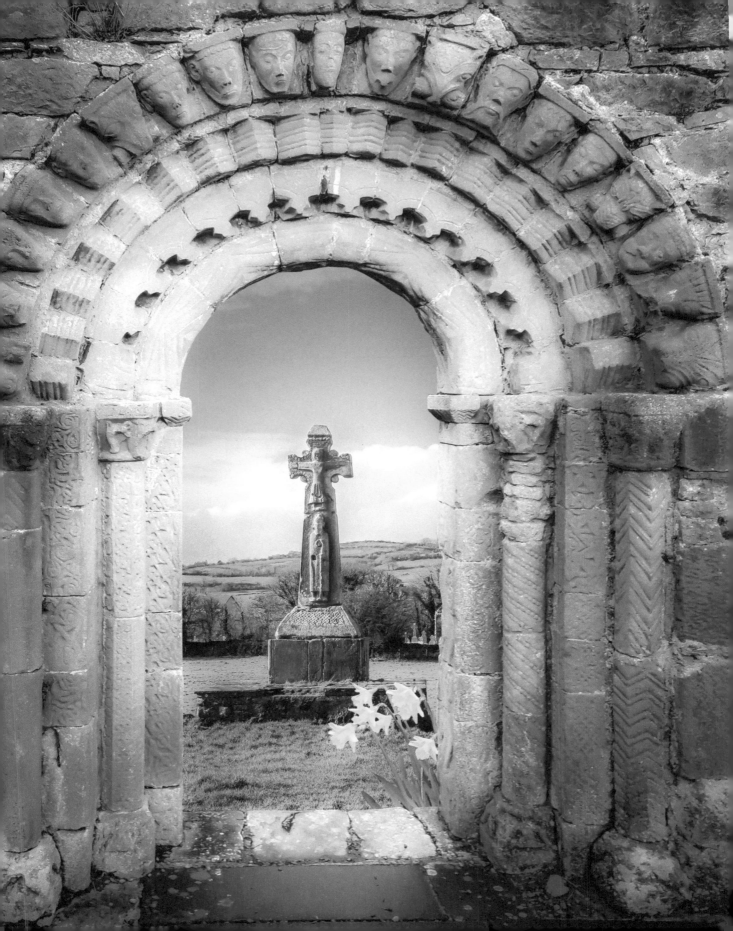

Irish Summer through Kildysart Church Ruins

This beautifully crafted frame is one of the windows in the ruins of the church in Kildysart Graveyard. The flowers are planted each year by the local Kildysart Tidy Towns group along the road entering the village, along the shores of the Shannon Estuary.

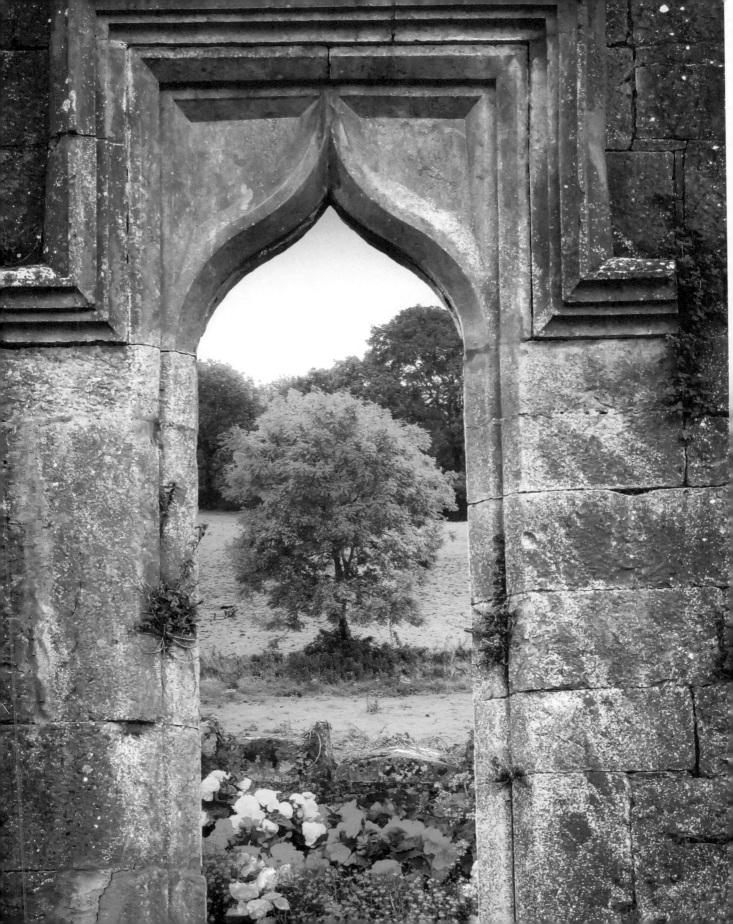

Clare Abbey Sunrise

An Irish sun rises over the County Clare countryside as viewed through one of the Gothic arched windows in the ruins of Clare Abbey, an Augustinian monastery established in 1195 near Ennis.

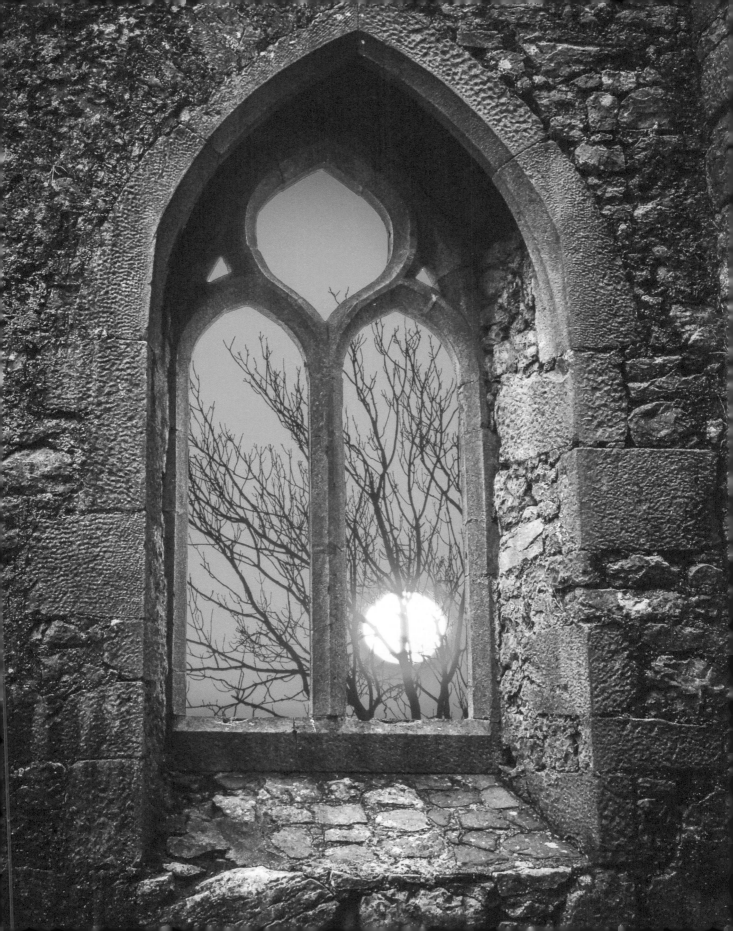

Sunset at Medieval Clare Abbey

This Medieval window from the side of the ruins of Clare Abbey in County Clare frame one of Ireland's spectacular sunsets.

Clare Abbey Window at Sunrise

A vibrant and luscious County Clare sunrise is viewed through this intricately designed window in the ruins of Medieval Clare Abbey.

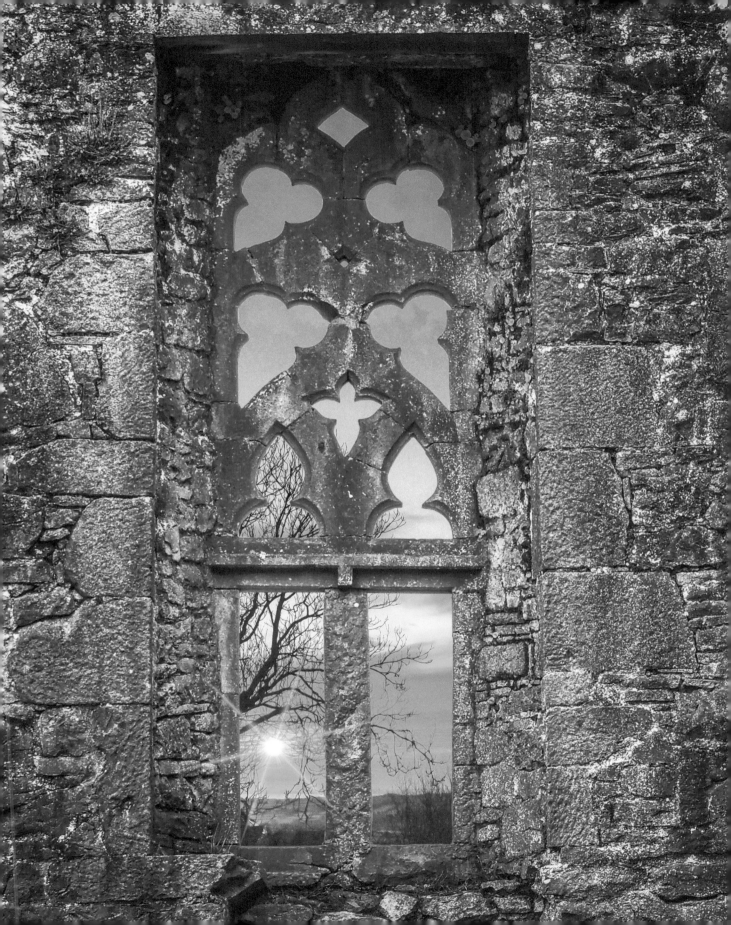

Summer Sunrise at Clare Abbey

A spectacular County Clare sunrise fills this ornate window in the ruins of the cathedral at Clare Abbey, built in 1195. This window would have been filled with stained glass, an important art form of the Middle Ages, used for storytelling and recording history.

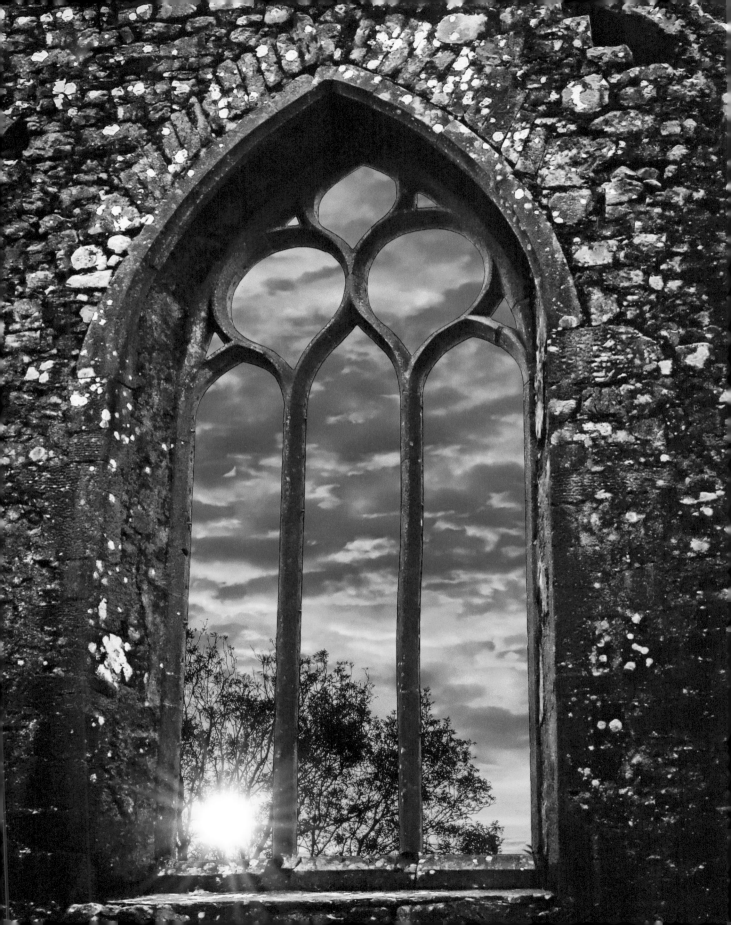

Shannon Sunrise through Medieval Arch

Looking through this enchanted Medieval portal, a doorway from the 12th Century St. Tola's Church near Corofin in County Clare, a vibrant Spring sunrise paints the sky over the Shannon Estuary.

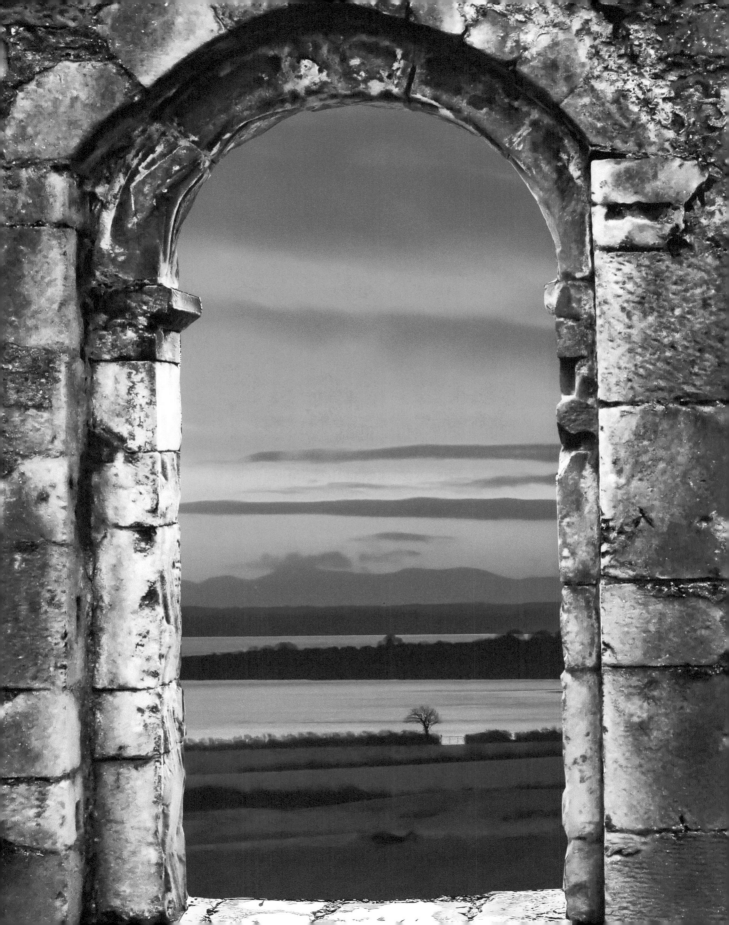

Aran Islands Celtic Cross & Fishing Vessel

From the isle of Inisheer (Inis Oirr) in County Galway's Aran Islands, this image features a view from the hilltop graveyard with a weathered Celtic cross and passing fishing vessel on the Atlantic Ocean. Located in the same graveyard, this stone arch is in the previously buried ruins of the 10th Century Teampall Chaomhan, a church established by St. Chaomhan, brother of St. Kevin, founder of Trinity Church at Glendalough, County Wicklow.

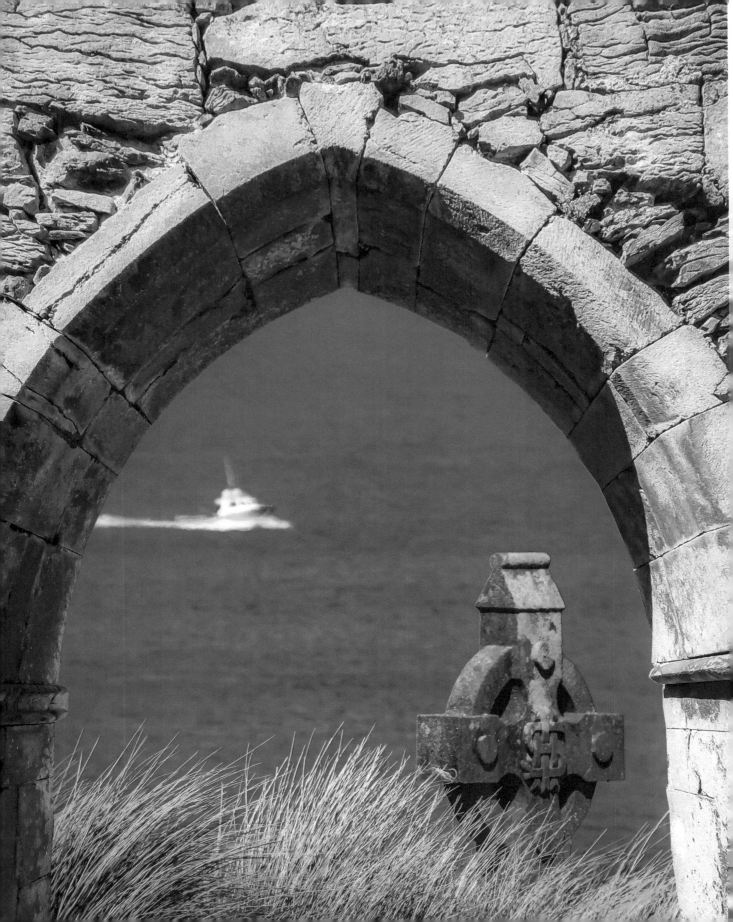

County Clare Atlantic Storm

A doorway into the ruins of a church in the Kilmurry-Ibrickane graveyard frames a view of a storm brewing in the distance from the seaside village of Lahinch. Lahinch is a popular surfing spot, and the graveyard has graves dating back to 1777.

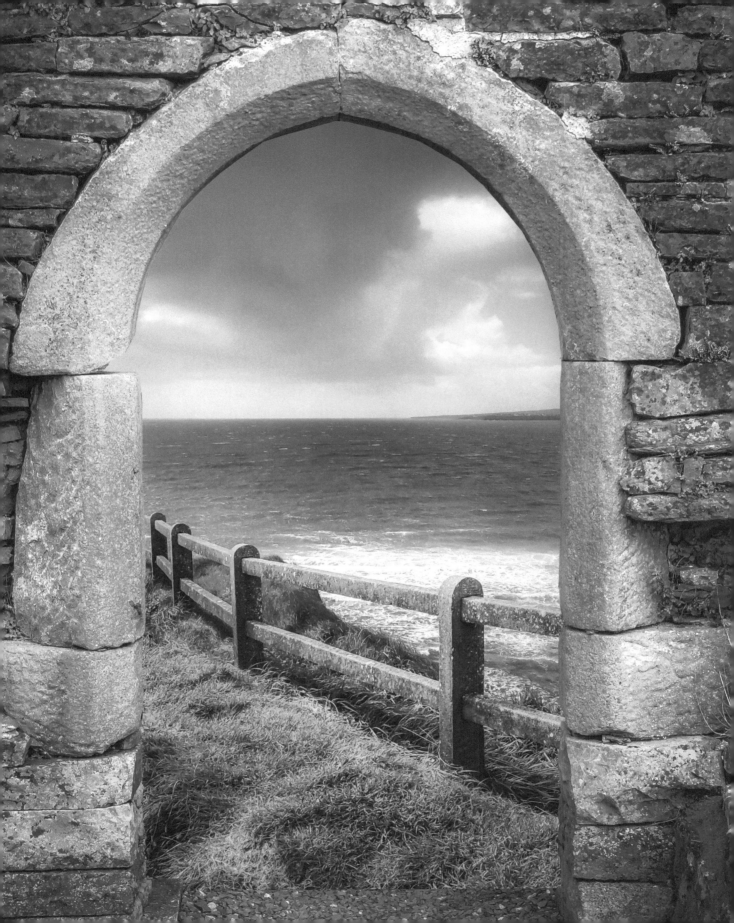

Serene Sunset over County Clare

Alone Iris blooms in the tranquil meadows of County Clare at sunset, viewed through the ornate frame of a crypt in the ruins of Quin Abbey, a 13th Century monastery.

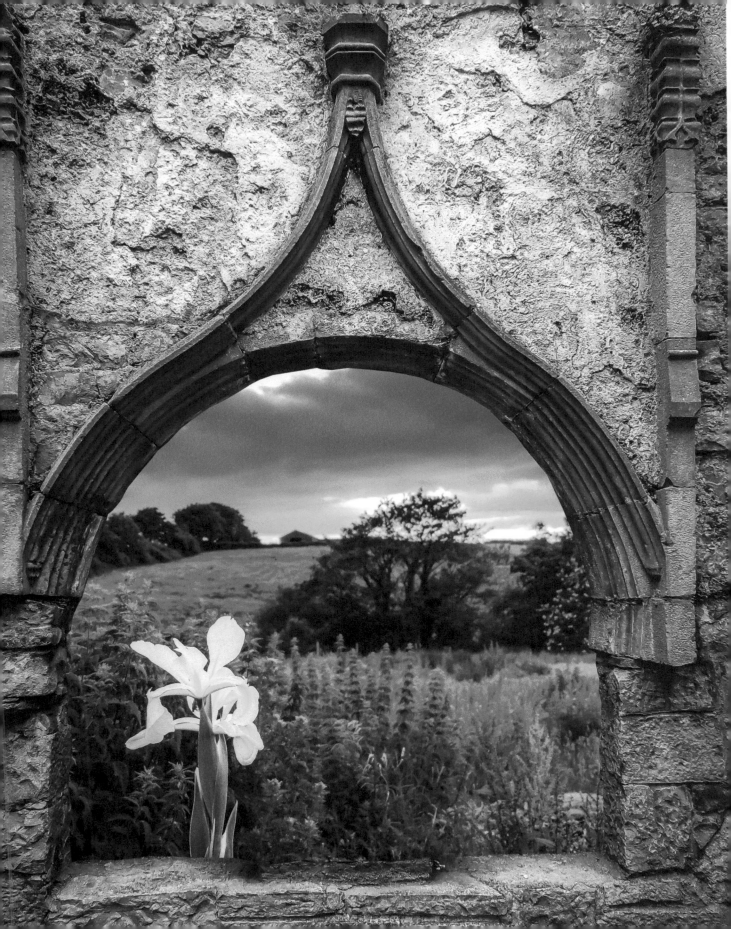

Dandelion Meadow in County Clare

Looking through this stone doorway of an old Miller's cottage, wildflowers bloom in a meadow in the magical County Clare countryside. The wildflowers are a brilliant red Foxglove and thousands of dandelions.

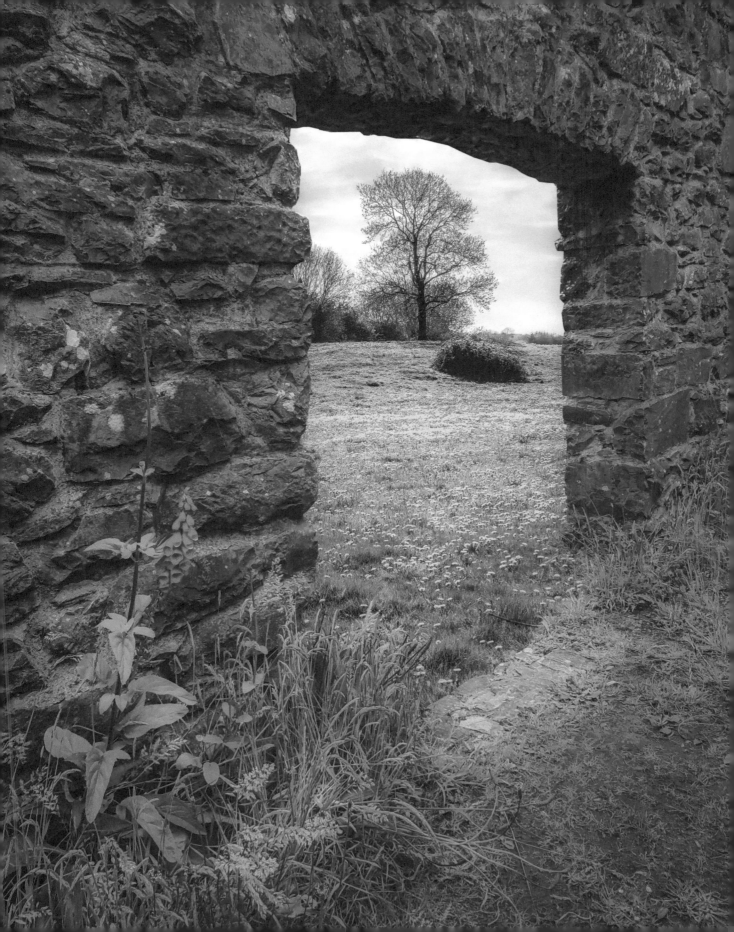

Into the Magical Irish Countryside

This deteriorating entrance to an abandoned cottage in County Clare frames a magnificent meadow filled with Summer wild flowers in County Cork.

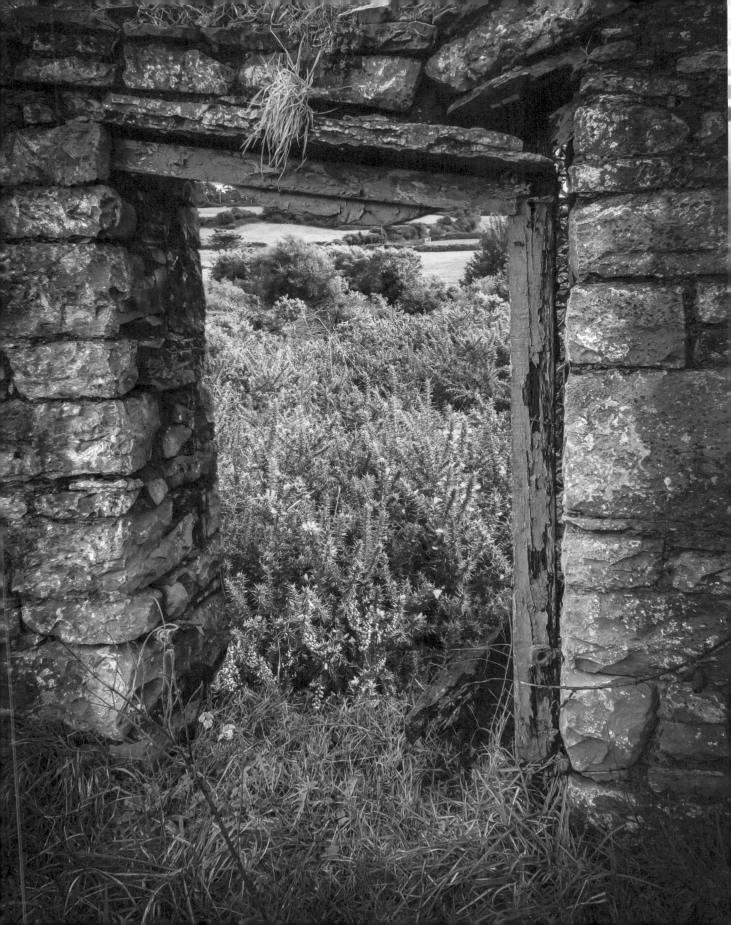

Kilmacduagh Round Tower in Summer

An arched entrance to County Galway's Kilmacduagh Monastery, established in the 7th Century, frames this view of the Medieval site's Round Tower, which once served as a sort of "panic room" for residents during those unsettling times. The tower is believed to have been built in the 12th Century. The Red Valerian flowers bloom each Summer on a grave near the tower.

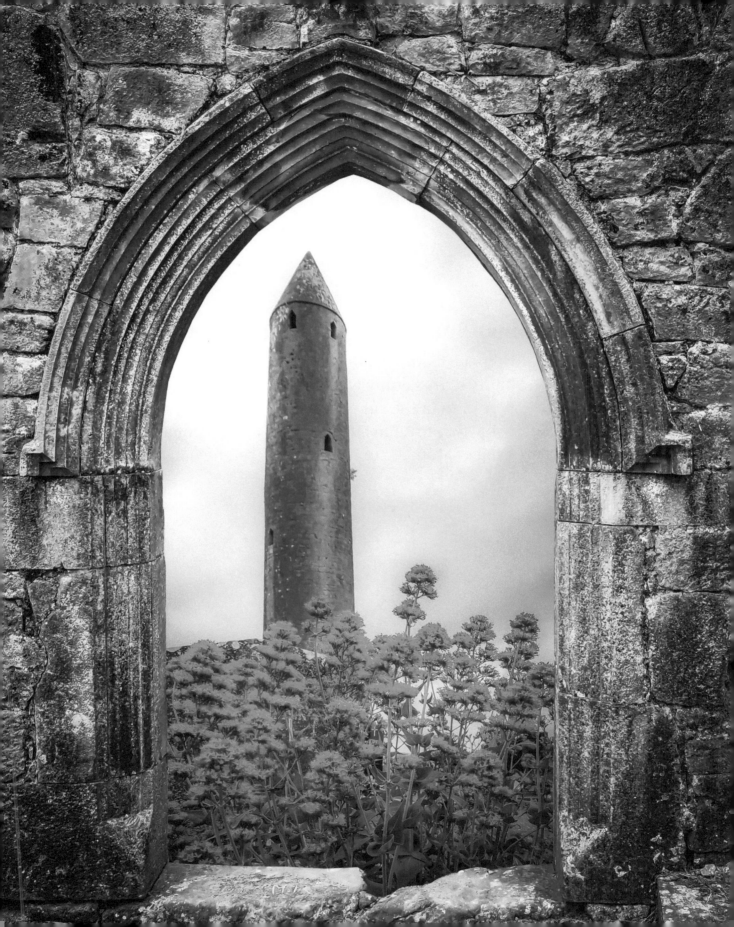

Summer Solstice in the Irish Countryside

This image features a bright and beautiful view of the County Clare countryside as seen through a decorative arch in the ruins of Corcomroe Abbey, a Cistercian monastery established around 1182 by Donal Mor O'Brien, King of Munster, in Ireland's Burren Region.

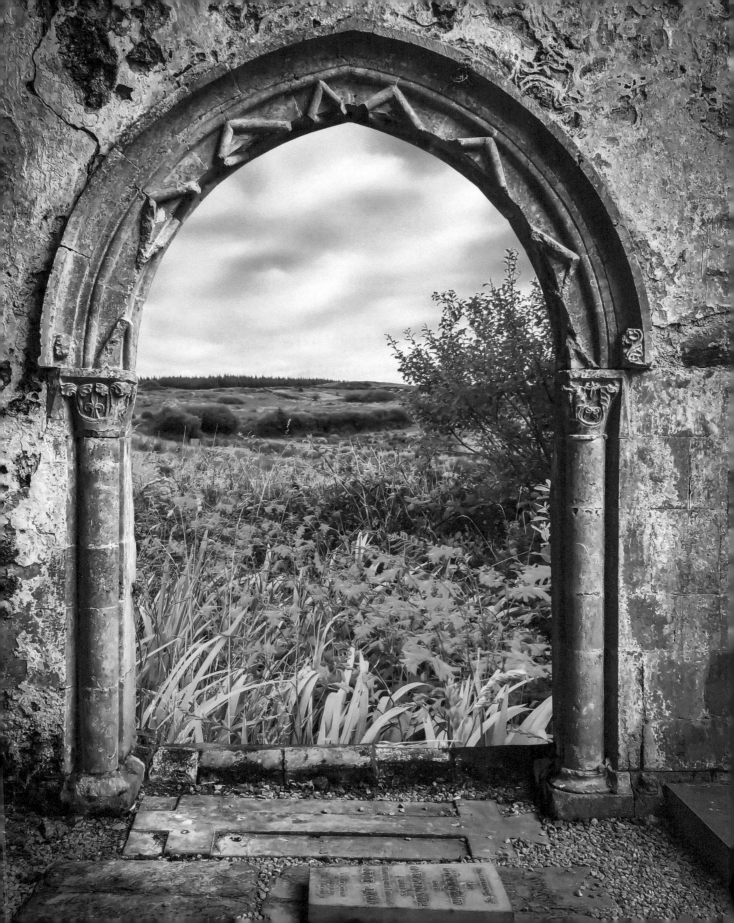

Medieval Arch, White Horse and Monochrome Rainbow

This 12th Century Medieval Arch from the ruins of Corcomroe Abbey frames a horse grazing in a meadow of wildflowers in County Clare as a unique monochrome rainbow lights the sky.

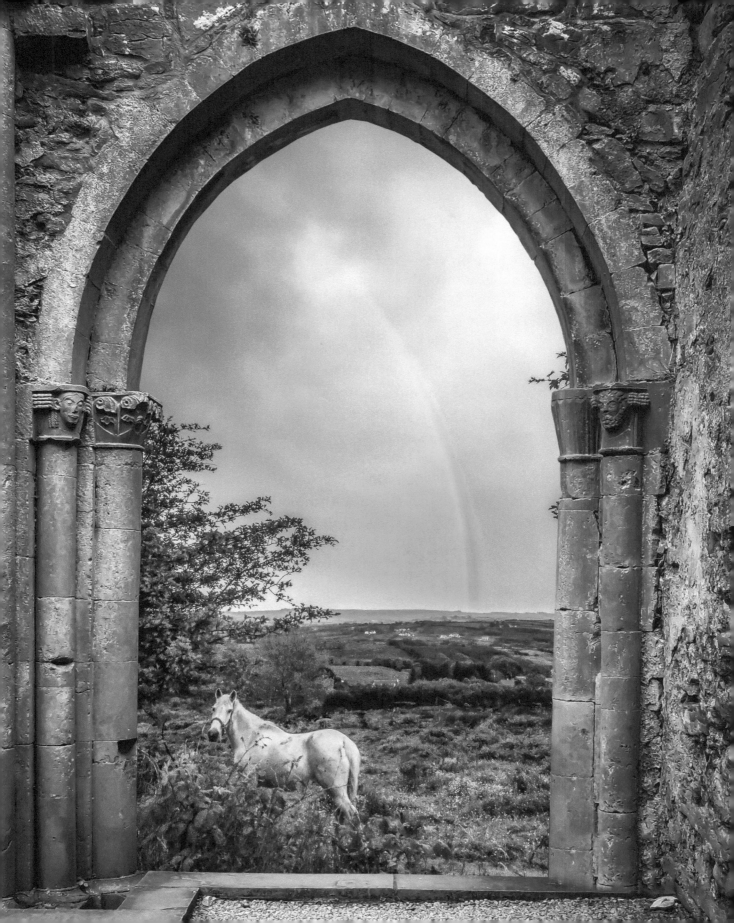

Acknowledgements

So many people have provided support and encouragement during the conception and ultimate publication of this book. I appreciate you all, and am grateful for your friendship, guidance and presence in my life.

Thank you!

Michael McNamara

Bridget, Tommy, Rachael, Michaela & David McNamara Brown

Ellen, Lisa, Shona, Kaithlynn & Madyson McNamara

Joe & Mary McNamara, John McNamara,

Bridget McNamara Clarke, Noreen McNamara Ruede,

Anne McNamara Irwin, Kathleen McNamara Pedersen

Vislan Alberto Truett Prado

Francis, Helen & Anthony Murphy

Maureen & John Ginnane

Sue McGovern Downward

Bridget O'Sullivan

David & Elizabeth Odell

Charles, Marilyn & Chuck Hansen

Celeste Eubanks Goering

Anne Bowman Lackey

Donna Winkhart Lab

Vivienne Nichols

Anthony & John Cavanagh

Michael Michael

Noel & Eimear O'Grady

Eddie & Yvonne Murphy

Dr. Finbar Fitzpatrick

Pat & Michelle McMahon

Pauline McDermott-Smith, *Ireland of a Thousand Welcomes*

Tim Keane, *Ireland's Natural Beauty*

More kind words from Fans...

"Sus puertas y ventanas son preciosas." ~ **Olga Olmedo**

"Your images are just beautiful. I now live in Australia, but you bring Ireland into my life daily with your photographs. Thank you." ~ **Ann Downey**

"I have purchased all of these beautiful books and enjoyed each one immensely! James captures breathtakingly gorgeous scenes of Ireland as only he can! You can bring The Emerald Isle into your home!" ~ **Susan Pendergrass**

"My good friend, James, whom I just haven't had the pleasure of meeting yet, has the marvellous ability to capture the natural beauty and charm of Ireland that we often miss in our travels. Hopefully, we'll cross our paths on one of the many quaint boreens of Ireland. Thanks, James, for your inspiring works. Slainte." ~ **Barbara K. DePaul**

"I love all of your photography but especially your work on 'Irish Doorways and Windows'! The pictures always make me see the beauty that lies there through your eyes. At times I feel as though I'm peering into a wee fairyland!" ~ **Ellen Cooper**

"These unforgettable portals allow us to maybe sit a while amidst all of this splendour. They are a reflection of the beauty and magic of Ireland." ~ **Ann Brassey Hindson**

"Looking at these wonderful, magical windows & doorways is like going back in time in his beautiful photos when I wish I could have met my ancestors!" ~ **Karla Bounds**

"Your stunning photos bring magic and joy to anyone who views them. The doorway series are like portals into faraway lands. You are waiting to see fairies and elves peeking around a corner. Beautiful work." ~ **Patsy Macdonald**

"You capture the little things that go unnoticed in every day life. Each photo elicits a warm feeling, a memory, a wish for wandering, and a hope that one day we will pass this way to see what you have captured for all to notice. Thank you!"
~ **Judy Brady Witherspoon**

"Your photos transport me back to the country of my birth, some places I've visited and some on my bucket list." ~ **Angela Irwin**

"Your books, prints and postings help me through my days and weeks."
~ **Patricia Masters**

"Thanks to James, I get to see the most stunning, magical places in Ireland that I will never get to see. His work is beautiful." ~ **Sherry Michele**

About the Author

Growing up in Alaska, near the quaint hamlet of Ester, near Fairbanks, James A. Truett developed an appreciation for nature as a child, exploring the majestic wilderness of his home state both on the ground and in the air.

He began his career as a journalist and photographer for the local newspaper at the age of 14, picked up his private pilot's license at the age of 17, and by the age of 19, he had moved to Seattle and joined The Associated Press, eventually becoming one of the youngest journalists in the world to be published in every major newspaper in the world.

Over the years, he developed an avid interest in sailing and traveled extensively by boat, auto and air in the U.S., Canada, Mexico, Central America, Ireland and the UK.

After tracing his ancestral roots back to Ireland and falling in love with the beauty of the Irish countryside, he settled in County Clare from where he manages his portfolio of art, photography and publishing projects.

Connect with James A. Truett on Social Media:
www.JamesATruett.Com/social

Other Books by James A. Truett

Vol. I
Mystical Moods of Ireland:
Enchanted Celtic Skies, Book 1

Vol. II
Mystical Moods of Ireland:
Enchanted Celtic Skies, Book 2

Vol. III
Mystical Moods of Ireland:
Magical Irish Countryside

Vol. IV
Mystical Moods of Ireland
*In the Footsteps of W.B. Yeats at
Coole Park and Ballylee*

Vol. V
Mystical Moods of Ireland
*Book of Irish Blessings
& Proverbs*

*Available at all major
booksellers and*
MoodsofIreland.Com

*Follow James A. Truett's adventures
and get free previews of his books here:*
www.JamesATruett.Com/subscribe